Brush Pen Lettering Practice Book

Grace Song

ULYSSES PRESS

Published by:
Ulysses Press
P.O. Box 3440
Berkeley, CA 94703
www.ulyssespress.com

ISBN: 978-1-61243-828-3
Library of Congress Control Number: 2018944067

Printed in Colombia
20 19 18 17 16 15 14 13 12 11 10 9

Acquisitions: Bridget Thoreson
Managing editor: Claire Chun
Editor: Shayna Keyles
Proofreader: Renee Rutledge
Cover art: Grace Song
Interior design: Jake Flaherty
Author photo: © George Matthew Photography

CHAPTER 1

What You Need to Get Started

Brush Pens

This practice book is designed so that you can letter directly in the book. You will need smaller-tipped brush pens to do so. There are quite a variety of brush pens available, but I recommend a few of my favorite ones to get started:

- Pentel Fude Touch Sign Pen
- Tombow Fudenosuke Brush Pen, Hard Tip
- Tombow Fudenosuke Twin Tip

Here are a few other small-tipped brush pens you can try:

- Kuretake Disposable Pocket Brush Pen (Fine and Extra Fine Tip)
- Kuretake Bimoji Brush Pen (Fine and Extra Fine Tip)
- Pentel Pocket Brush Pen (Hard Tip)
- Pentel Fudemoji Brush Sign Pen (Fine and Extra Fine Tip)
- Pilot Fudegokochi Brush Pen (Extra Fine Tip)
- Pilot Fude-Makase Color Brush Pen (Fine or Extra Fine Tip)
- Pilot Futayaku Double-Sided Brush Pen
- Zebra Disposable Brush Pen (Fine and Super Fine Tip)
- Zebra Funwari Fude Color Brush Pen

Not all brush pens are created equal. Experiment with a variety of brush pens and find the one that is right for you. Generally speaking, brush pens with a harder tip are easier to control.

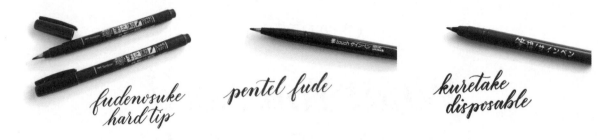

fudenosuke hard tip

pentel fude

kuretake disposable

Paper

Although you can practice directly in the book, it will be a great idea to have tracing paper handy. Tracing paper has a translucent quality and is made by several brands, including Canson, Strathmore, and Borden & Riley, just to name a few. You'll be able to place it on top of the practice pages and see the guides through it, giving you the ability to trace the examples and repeat any drills or exercises as needed. It is also very smooth, which means the tips of your brush pens will glide easily over the paper and avoid premature fraying.

Other types of paper that are smooth (but not translucent) are laser printer paper, marker paper, Bristol paper, and Rhodia brand paper.

Tips on Using the Guide

Work in succession: The practice book is organized so that you start off with the basics and then work on progressively more difficult drills and exercises. If you're brand new to brush pen lettering, avoid jumping around and work through the book in order.

Repeat exercises: Each section of this book is divided into several practice pages which may focus, for example, on a basic stroke, a combination of strokes, specific letters, common letter combinations, or words. You may want to repeat the exercises on a couple of pieces of paper to see improvement, or go back to the ones that you have difficulty with from time to time. This is when tracing paper will come in handy.

Date your work: In the corner of each practice page, there is a spot to write the date so that you can track your progress. When working on any new skill, you may not see progress from day to day, but you

will over several weeks, especially if you are practicing consistently. You'll be pleasantly surprised with what you can achieve in a relatively short period of time, as long as you put in the work!

Use a pencil: If you are focusing too much on controlling the pressure of the tip of the brush pen to create thin or thick strokes and not enough on the direction of the strokes, you can use a pencil to do the exercises in this book. Using a pencil will help you solely focus on the movement or direction of the strokes so you can build muscle memory.

Pay attention to guidelines: The guidelines in the book will help you determine the relative size of each stroke or letter and where they sit in relation to each other. When practicing, don't get sloppy. Hit the guidelines every single time; this is important for muscle memory and to keep your lettering looking consistent.

X-Height (X): The height of a letter's main body, not including ascenders and descenders (i.e., the space between the waistline and the baseline, or the height of the lowercase x).

Waistline (W): The line that goes across the top of a letter's x-height, not including ascenders.

Baseline (B): The line that goes across the bottom of a letter's x-height, not including descenders.

Ascender (A): The line to which the part of a letter that extends above its x-height reaches, such as in lowercase h.

Descender (D): The line to which the part of a letter that extends below its x-height reaches, such as in lowercase j.

CHAPTER 2

Brush Pen Ergonomics

The brush pen is a fabulous tool: It has a flexible tip that allows you to create thin and thick strokes, and the ink is already loaded for your convenience. Although seemingly simple, it does take a bit of time to get used to. You'll need to consider the way you hold the pen, your grip, and the relative position of the paper.

How to Hold a Brush Pen

The brush pen should be held at an approximately 45° angle relative to the surface of the paper. By doing this, the tip of the brush pen will better respond to different amounts of pressure that are applied while lettering. When applying light pressure, the tip of the brush pen will create thin strokes. Conversely, when applying heavy pressure, the side of the tip will make contact with the paper and create thick strokes. Avoid holding the brush pen perpendicular to the paper, as you will not be able to create a wide variety of strokes and the tip will fray much faster.

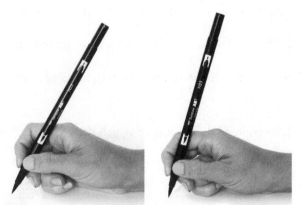

Holding the brush pen at an angle (approximately 45°) will allow you to easily apply differing pressures to create thin to thick strokes.

With this grip, the angle is too steep or upright. It will be difficult to create a greater variance of thicknesses in your strokes. You'll also fray your brush pens quickly!

Fingers are not too close to the tip.

Brush pen is held at an angle and the barrel of the pen is resting on the knuckle.

Gently push the barrel so that it rests in the webbing between your thumb and index finger.

This changes the angle, further allowing you to create a greater variety of strokes.

How to Grip a Brush Pen

A brush pen can be gripped in various ways and still produce a variety of strokes, as long as the tip of the pen lies at an angle approximately 45° to the paper. It may take some experimentation to see which grip works best. For example, you can try positioning your fingertips a little farther away from the tip than you usually do for a ballpoint pen. Doing this causes the angle of the brush pen to change slightly but will allow you to take advantage of the side of the tip to create wider strokes. Also, look at where the barrel of the brush pen sits in your hand. The closer it is to the webbing between your thumb and index finger, the more angled your brush pen becomes. Regardless of which grip you try, just ensure that the tip is angled to the paper. Try using different pressures, from light to heavy, with different grips, and see how much of a variance you can achieve in your stroke width.

How to Position your Paper

While sitting square at your desk, place the paper down in front of you at an angle. If you are right-handed, the paper will likely be rotated counter-clockwise, and it will likely be rotated clockwise if you are left-handed. Check your wrist—it should be in a neutral position, not bent inward or outward. Once you find the paper position that allows your wrist to stay neutral, keep the grip on your brush pen constant so that the angle of the pen relative to the paper also stays constant. While lettering, you should be able to keep the position of the paper, your grip, and the angle of the pen the same. Another way to determine whether the paper position is correct for you is to see if the dotted slant lines on the practice pages point directly toward your chest. This is because you should be pulling the brush pen directly toward your chest when making downstrokes.

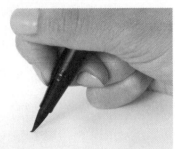 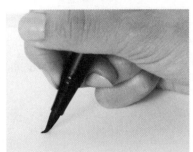 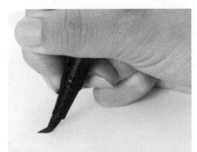

Light pressure Medium pressure Full/heavy pressure

Applying Pressure

The beauty of the brush pen is realized when pressure is applied to its flexible tip! All upstrokes are thin, so use light pressure on the tip when moving upward. All downstrokes are thick, so apply heavy pressure while moving downward. Heavy pressure causes the tip to bend and make greater contact with the paper, which creates a thick stroke. Remember, holding the brush pen at an angle will allow you to create contrast between your thin and thick strokes.

CHAPTER 3

Brush Pen Warm-Up

Before diving into the meaty part of this book, let's take a moment to get to know the brush pen. These exercises will help you get a feel for how much pressure you will or won't need to make thick or thin strokes.

You can also use this page to warm up before each practice session or when testing out a new brush pen.

WARM-UP DRILLS

Light pressure

Medium pressure

Heavy pressure

CHAPTER 4

Basic Strokes

The basic strokes are a series of common shapes that are key to building a strong foundation in lettering. All the letterforms are created by a combination of two or more of these basic strokes. Think of them as individual shapes that you piece together like a puzzle. This will all make sense once you start connecting them in Chapters 5 and beyond.

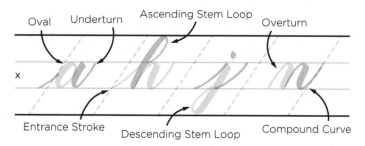

From this point on, here are some tips to keep in mind as you progress through the workbook:

Aim for consistency: Consistency is the name of the game. The size, shape, and slant of your strokes or letters should be the same every single time.

Letter and look back: After doing a whole row, assess what was done well and celebrate those small wins. Now, what needs improvement? Compare your form to the exemplar and choose one thing to improve. Focus on making that improvement in the next row. Keeping your practice sessions focused is far better for progress than practicing mindlessly.

Shakiness: As a beginner, you may experience shaky lines, especially on the upstroke. This will improve with practice. I promise!

Go slow: Take your time and notice the way the tip of the pen moves with differing amounts of pressure. When you rush, your form becomes sloppy.

BASIC STROKES

Entrance Stroke

Date: _____

This stroke is used at the beginning of a letterform. At the end of a letter, this stroke is referred to as an exit stroke. When connecting letters, it serves as a connecting stroke.

Start at the baseline and with consistent, light pressure, move up toward the waistline with a slight curve.

Trace.

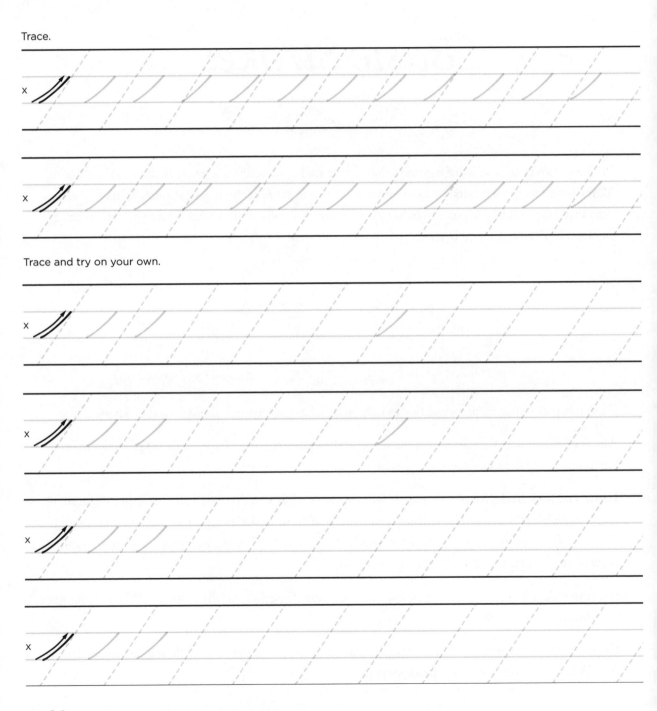

Trace and try on your own.

BASIC STROKES

Underturn

The underturn is found in lowercase letters, such as a, i, u, and w.

Start off with full pressure at the waistline, then as you move toward the baseline, gradually release pressure. By the time you hit the baseline, you should be using light pressure to create a thin line. Continue upward with light pressure to the waistline.

Trace.

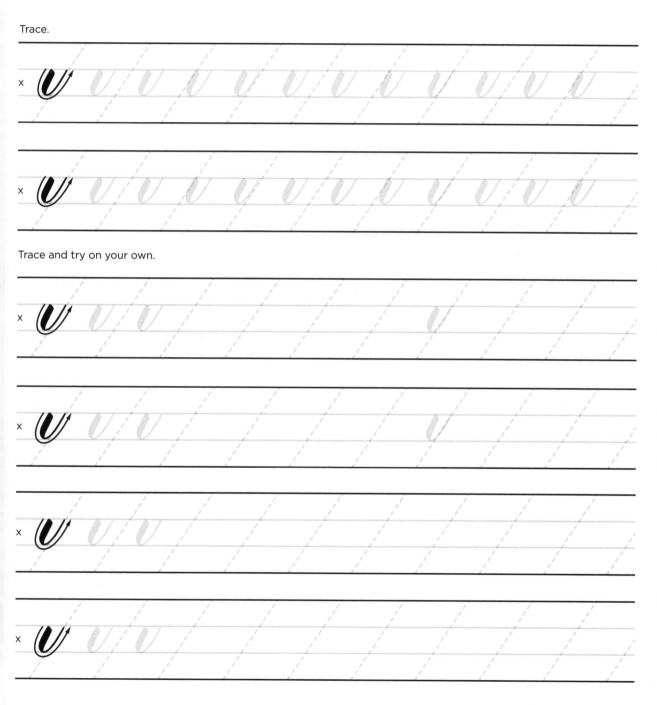

Trace and try on your own.

BASIC STROKES

Overturn

The overturn is found in lowercase letters such as m and n. It is the opposite of the underturn.

Start with light pressure at the baseline, move upward, and continue with constant, light pressure until you hit the waistline. Then curve downward, gradually increasing the pressure to finally hit the baseline at full pressure.

Trace.

Trace and try on your own.

BASIC STROKES

Compound Curve

Date: _____

The compound curve is a combination of the overturn followed by the underturn. It is used in lowercase letters such as h, m, v, and y.

Start at the baseline with light pressure, hit the waistline, and curve around. Once you move downward, gradually add pressure. As you get closer to the baseline, gradually release pressure. Hit the baseline with light pressure and curve back upward with light pressure until you hit the waistline.

Trace.

Trace and try on your own.

BASIC STROKES

Oval

The oval is used for lowercase letters a, d, g, o, and q.

At the 2 o'clock position, start with light pressure and turn counterclockwise. After you hit the waistline and curve downward, start increasing pressure. As you move toward the baseline, gradually decrease pressure until you hit the baseline with a thin line. Continue moving upward with light pressure to close the loop.

Trace.

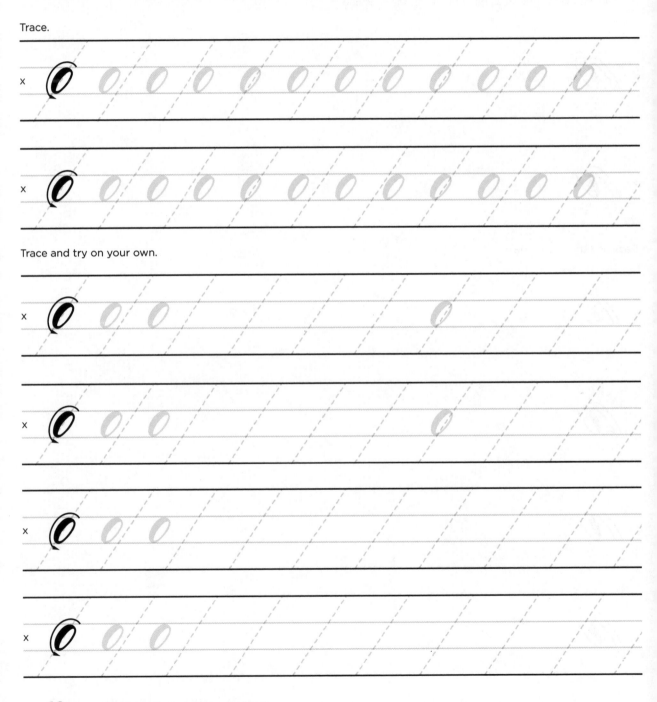

Trace and try on your own.

BASIC STROKES

Ascending Stem Loop

Date: _____

The ascending stem loop is used in lowercase letters b, d, f, h, k, and l. It forms the top part of most letters that extend above the waistline.

Start at the waistline with light pressure and curve up toward the ascender line. As you curve around counterclock - wise, start increasing pressure. Continue at full pressure all the way to the baseline.

Trace.

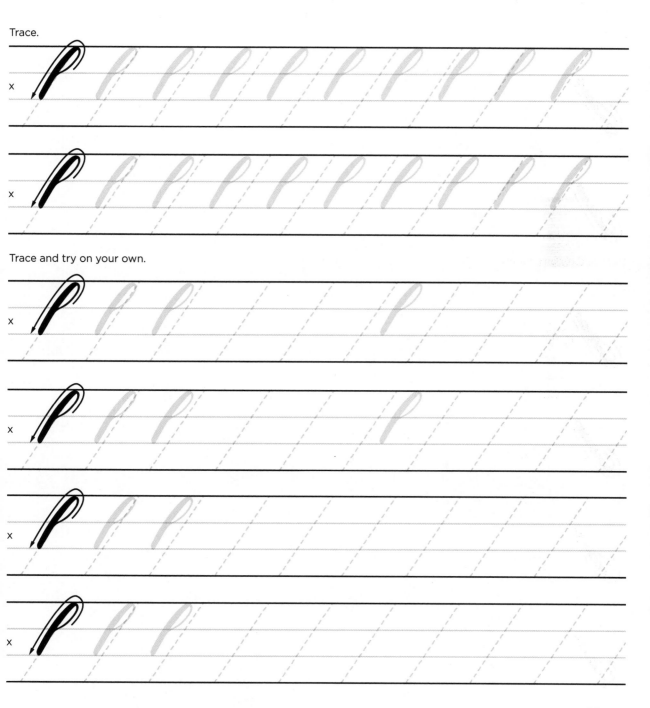

Trace and try on your own.

BASIC STROKES

Descending Stem Loop

The descending stem loop is found in lowercase letters g, j, p, and y. It forms the bottom part of most letters that extend below the baseline.

Start at the waistline with full pressure and move past the baseline. Gradually release pressure so that you hit the descender line with light pressure. Move clockwise with a thin stroke and continue upward with light pressure to the baseline.

Trace.

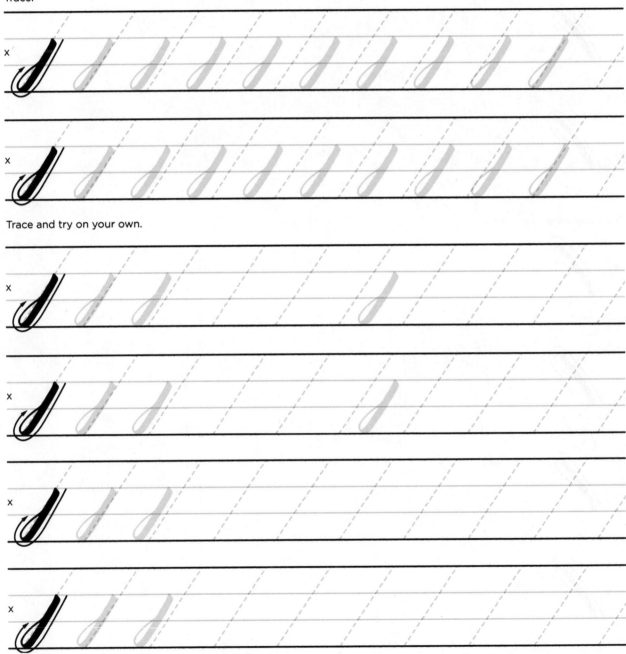

Trace and try on your own.

BASIC STROKES

Full-Pressure Stroke

Date: _____

The full-pressure stroke is a downstroke that is evenly thick throughout. You can find it in parts of other strokes such as the ascending and descending stem loops.

Starting at the ascender line at full pressure, move downward, keeping the pressure constant, and stop at the baseline.

Trace.

Trace and try on your own.

CHAPTER 5

Connecting Basic Strokes

Now that you have the basic strokes under your belt, let's begin to put them together in a series of different combinations. Through these exercises, you will learn how these "puzzle pieces" fit together.

Unlike cursive handwriting, lettering requires you to lift your pen off the paper after each stroke. Lifting slows you down, but it means that your form and connections will be cleaner.

CONNECTING STROKES

Tip

Date: _____

When connecting, lift after each stroke!

CONNECTING STROKES

Tip

When connecting to an oval, shorten the connecting stroke as shown in the second row.

x _m_ _m_ _m_ _m_ _m_ _m_ _m_

x _o_ _o_ _o_ _o_ _o_ _o_ _o_

x _o_ _o_ _o_ _o_ _o_ _o_ _o_

x _l_ _l_ _l_ _l_ _l_ _l_ _l_

x _l_ _l_ _l_ _l_ _l_ _l_ _l_

x _l_ _v_ _v_ _v_ _v_ _v_ _v_

x _h_ _h_ _h_ _h_ _h_ _h_

CONNECTING STROKES

Tip

Briefly pause after each stroke and visualize where and how the next stroke should be placed.

CONNECTING STROKES

Reverse the descending stem loop in the second row to create the letter q.

x *g* *g* *g* *g* *g* *g*

x *q* *q* *q* *q* *q* *q*

x *q* *q* *q* *q* *q* *q*

x *y* *y* *y* *y* *y* *y*

x *y* *y* *y* *y* *y* *y*

x *v* *v* *v* *v* *v* *v*

x *v* *v* *v* *v* *v* *v*

CHAPTER 6

Lowercase Alphabet

The next series of guide sheets contain the full lowercase alphabet, along with samples of alternate letterforms. Although the letters are presented in alphabetical order, I highly suggest practicing letters in groups based on a common basic stroke they share.

For example, if you'd like to improve on your oval form, practice letters like a, d, g, o, and q at the same time. Likewise, if you'd like to work on the underturn, practice letters like a, i, u, and w. Note that a letter can fall into more than one group; for example, the letter a.

Practicing letters in groups reinforces your muscle memory for the particular basic stroke you are focusing on.

Letters containing the underturn (or a variation of it):

a i r t u w

Letters containing the overturn (or a variation of it):

m n z

Letters containing the compound curve:

h m n v x y

Letters containing the oval (or a variation of it):

a b c d e g o p q s

Letters containing the ascending stem loop (or a variation of it):

b d f h k l

Letters containing the descending stem loop (or a variation of it):

f g j p q y z

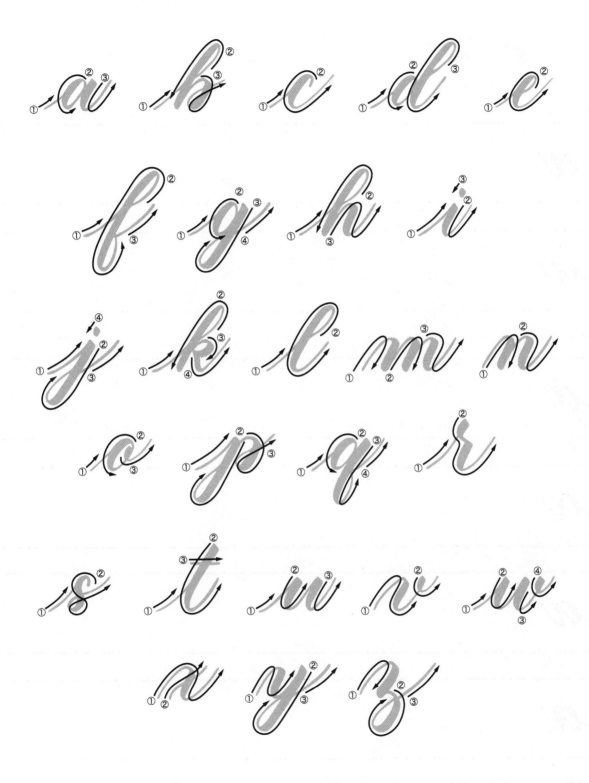

LOWERCASE ALPHABET

Letter a

Date: _____

Order of Strokes

① *a* ② *a* ③ *a*

Trace.

x *a a a a a a a a a a a a a*

x *a a a a a a a a a a a a a*

Trace and try on your own.

x *a a a*

x *a a a*

x *a a*

x *a a*

LOWERCASE ALPHABET

Letter b

Order of Strokes

① ② ③

Trace.

Trace and try on your own.

LOWERCASE ALPHABET

Letter c

Order of Strokes

① ② 𝒸

Trace.

Trace and try on your own.

Letter d
Order of Strokes

① ② ③

Trace.

Trace and try on your own.

Date: _____

Letter e

Order of Strokes

① ② 𝓮

Trace.

Trace and try on your own.

Letter f

Date: _____

Order of Strokes

① ② ③

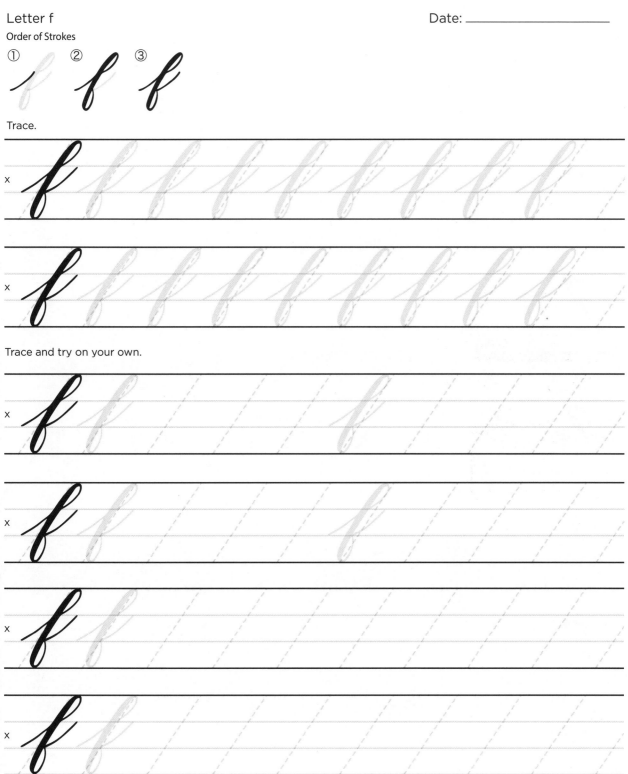

Trace.

x

x

Trace and try on your own.

x

x

x

x

Letter g

Date: _____

Order of Strokes

① ② ③ ④

Trace.

Trace and try on your own.

Letter h

Date: _____

Order of Strokes

① h ② h ③ h

Trace.

x h h h h h h h h h

x h h h h h h h h h

Trace and try on your own.

x h h h

x h h h

x h h

x h h

LOWERCASE ALPHABET

Letter i

Order of Strokes

① ② ③

Trace.

x

x

Trace and try on your own.

x

x

x

x

LOWERCASE ALPHABET

Letter j

Date: _____

Order of Strokes

① ② ③ ④

Trace.

x

x

Trace and try on your own.

x

x

x

x

Letter k

Order of Strokes

① ② ③ ④

k *k* *k* *k*

Trace.

x *k* *k* *k* *k* *k* *k* *k* *k* *k* *k*

x *k* *k* *k* *k* *k* *k* *k* *k* *k* *k*

Trace and try on your own.

x *k* *k* *k*

x *k* *k* *k*

x *k* *k*

x *k* *k*

LOWERCASE ALPHABET

Letter l

Date: _____

Order of Strokes

① ②

Trace.

x

x

Trace and try on your own.

x

x

x

x

Letter m

Date: _____

Order of Strokes

① m ② m ③ m

Trace.

x m m m m m m

x m m m m m m

Trace and try on your own.

x m m m

x m m m

x m m

x m m

Letter n

Date: _____

Order of Strokes

① n ② n

Trace.

x n n n n n n n n n

x n n n n n n n n n

Trace and try on your own.

x n n n

x n n n

x n n

x n n

Letter o

Date: _____

Order of Strokes

① ② ③

Trace.

x

x

Trace and try on your own.

x

x

x

x

LOWERCASE ALPHABET

Letter p

Date: _____

Order of Strokes

① ② ③

Trace.

Trace and try on your own.

LOWERCASE ALPHABET

Letter q

Date: _____

Order of Strokes

① ② ③ ④

Trace.

x q q q q q q q q

x q q q q q q q q

Trace and try on your own.

x q q q

x q q q

x q q

x q

Letter r

Date: _____

Order of Strokes

① ②

Trace.

x

x

Trace and try on your own.

x

x

x

x

Letter s

Order of Strokes

Trace.

Trace and try on your own.

LOWERCASE ALPHABET

Letter t

Order of Strokes

Date: _____

① ② ③

Trace.

Trace and try on your own.

Letter u

Order of Strokes

① ② ③

Trace.

x

x

Trace and try on your own.

x

x

x

x

Letter v

Date: _____

Order of Strokes

① 𝓋 ② 𝓋

Trace.

x 𝓋 𝓋 𝓋 𝓋 𝓋 𝓋 𝓋 𝓋 𝓋

x 𝓋 𝓋 𝓋 𝓋 𝓋 𝓋 𝓋 𝓋 𝓋

Trace and try on your own.

x 𝓋 𝓋 𝓋

x 𝓋 𝓋 𝓋

x 𝓋 𝓋

x 𝓋 𝓋

LOWERCASE ALPHABET

Letter w

Date: _____

Order of Strokes

① ✎w ② ✎w ③ ✎w ④ ✎w

Trace.

x ✎w w w w w w w w

x ✎w w w w w w w w

Trace and try on your own.

x ✎w w w

x ✎w w w

x ✎w w

x ✎w w

Letter x

Date: _____

Order of Strokes

① 𝓍 ② 𝓍

Trace.

x 𝓍 𝓍 𝓍 𝓍 𝓍 𝓍 𝓍 𝓍

x 𝓍 𝓍 𝓍 𝓍 𝓍 𝓍 𝓍 𝓍

Trace and try on your own.

x 𝓍 𝓍 𝓍

x 𝓍 𝓍 𝓍

x 𝓍 𝓍

x 𝓍 𝓍

Letter y

Date: _____

Order of Strokes

① 𝒚 ② 𝒚 ③ 𝒚

Trace.

x 𝒚 𝒚 𝒚 𝒚 𝒚 𝒚 𝒚 𝒚 𝒚 𝒚

x 𝒚 𝒚 𝒚 𝒚 𝒚 𝒚 𝒚 𝒚 𝒚 𝒚

Trace and try on your own.

x 𝒚 𝒚 𝒚

x 𝒚 𝒚 𝒚

x 𝒚 𝒚

x 𝒚 𝒚

LOWERCASE ALPHABET

Letter z

Date: _____

Order of Strokes

Trace.

Trace and try on your own.

Alternate Letterforms

Date: _____

Alternate Letterforms

Date: _____

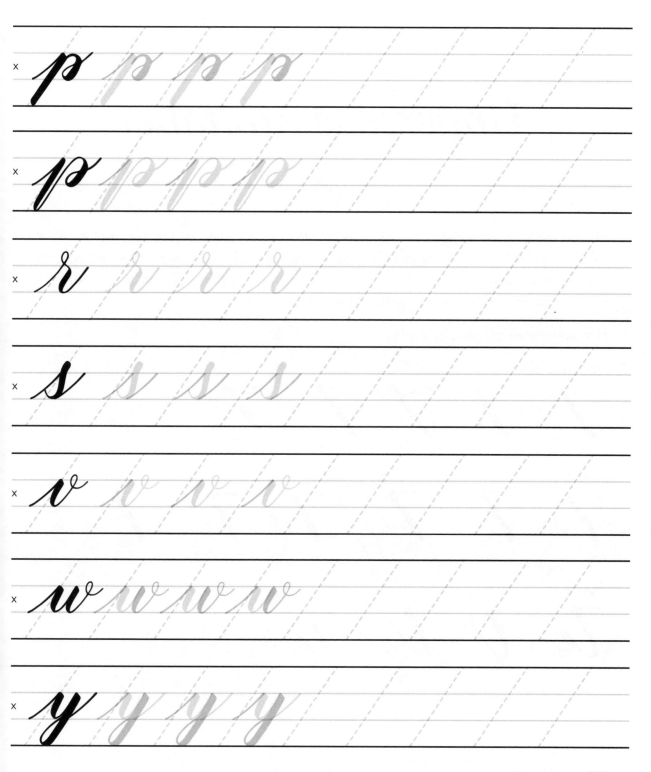

CHAPTER 7

Uppercase Alphabet

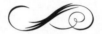

Just like the lowercase alphabet, the uppercase alphabet practice pages are organized alphabetically. Although the strokes in uppercase letters are not as straightforward as the ones in lowercase letters, you can still find common elements that are shared between certain letterforms. Remember to practice the uppercase letters in groups based on a stroke that they share.

Here are some sample groupings:

Group A:

F I J K L

Group B:

B D M N P R

Group C:

U V W Y

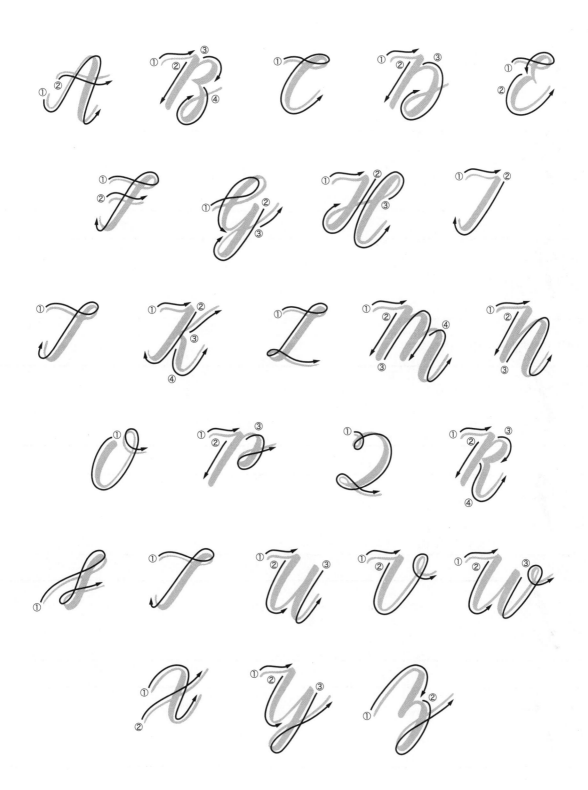

Letter A

Order of Strokes

Date: _____

① 𝒜 ② 𝒜

Trace.

x 𝒜 𝒜 𝒜 𝒜 𝒜 𝒜

x 𝒜 𝒜 𝒜 𝒜 𝒜 𝒜

Trace and try on your own.

x 𝒜 𝒜 𝒜

x 𝒜 𝒜 𝒜

x 𝒜 𝒜 𝒜

x 𝒜 𝒜 𝒜

Letter B

Order of Strokes

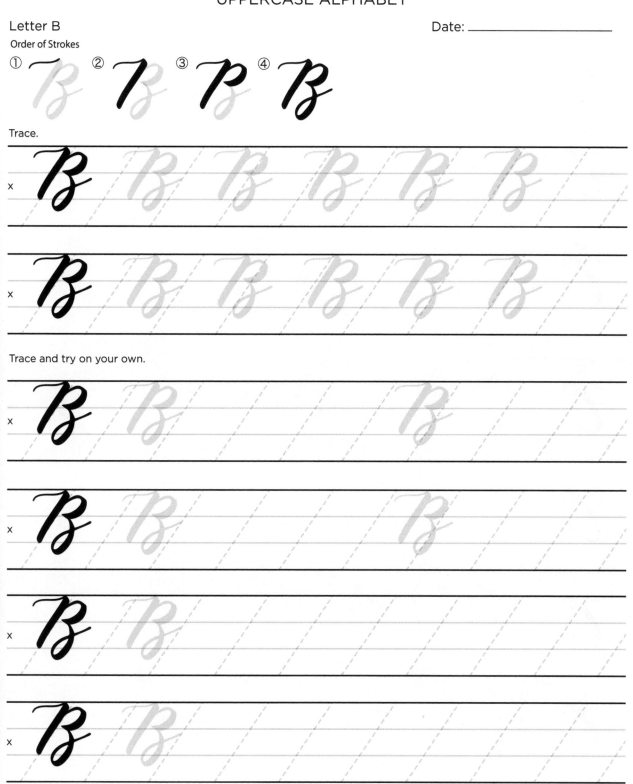

Trace.

Trace and try on your own.

Letter C

Order of Strokes

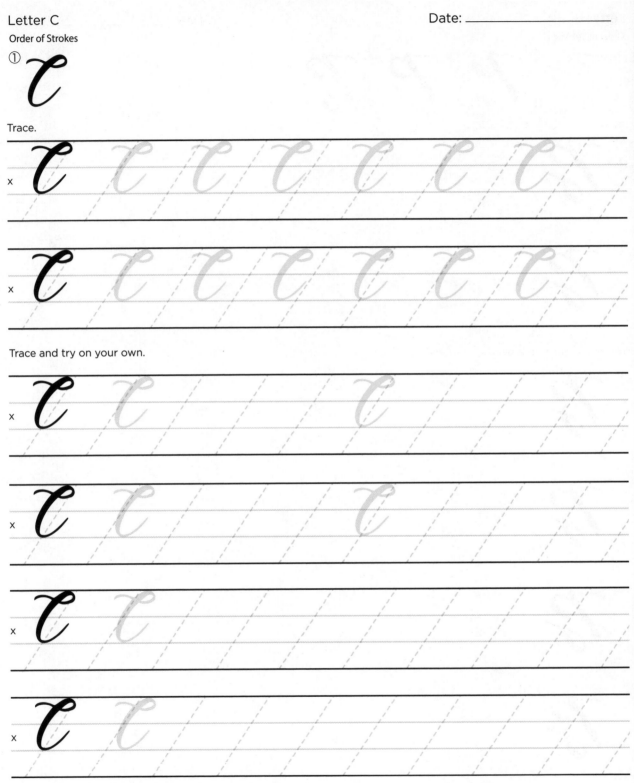

Trace.

Trace and try on your own.

Letter D

Order of Strokes

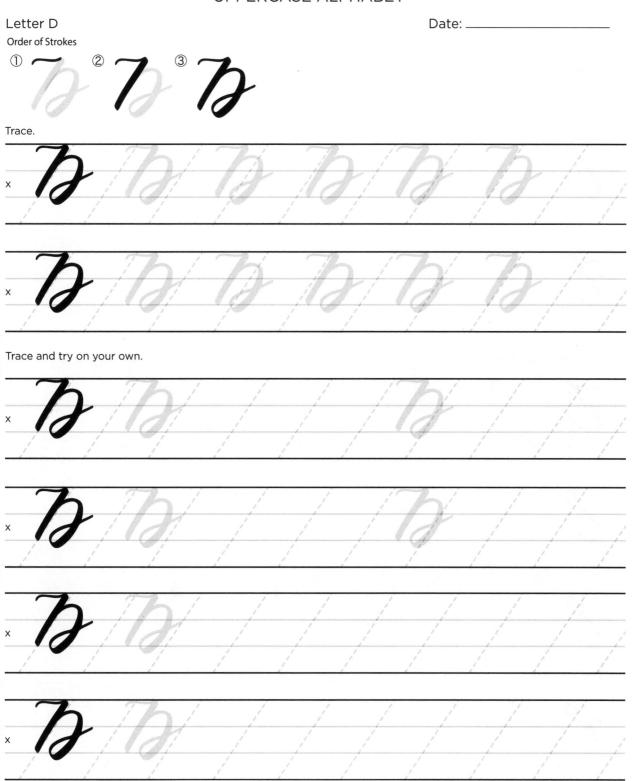

① ② ③

Trace.

x

x

Trace and try on your own.

x

x

x

x

Letter E

Date: _____

Order of Strokes

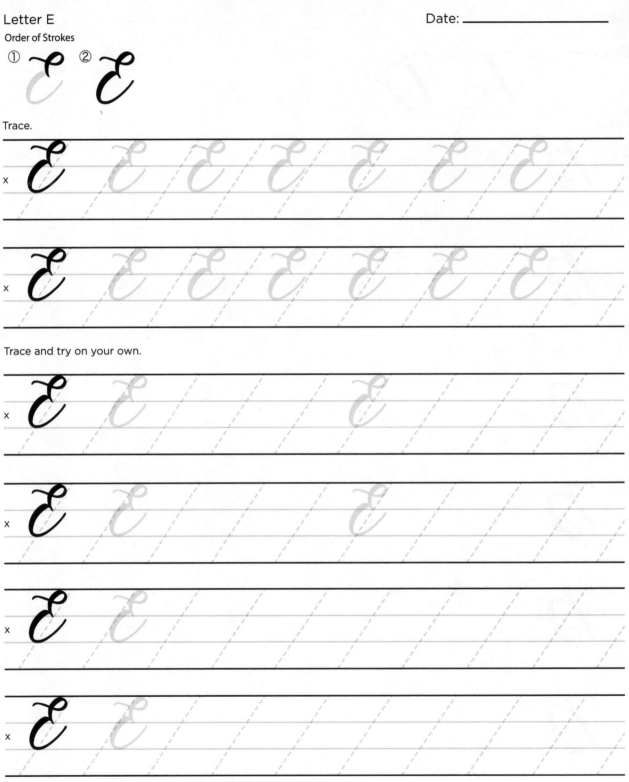

Trace.

Trace and try on your own.

Letter F

Date: _____

Order of Strokes

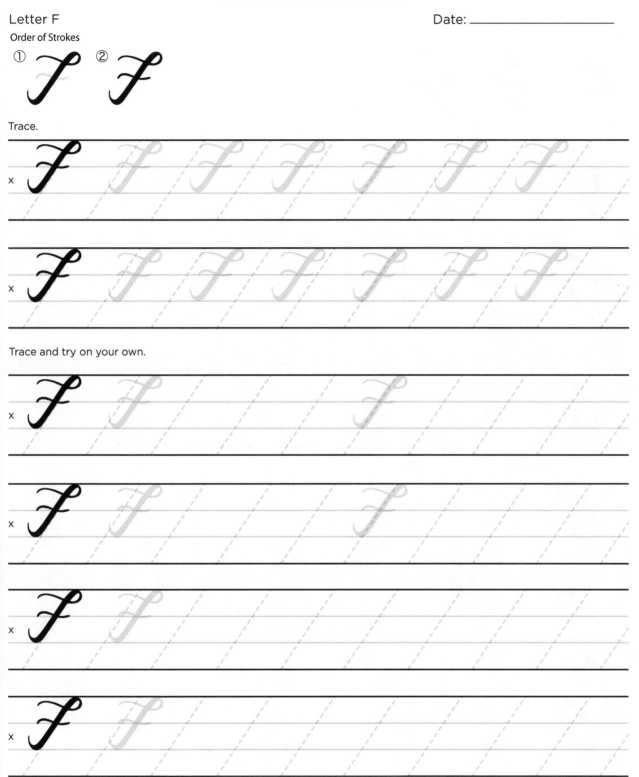

Trace.

Trace and try on your own.

Letter G

Date: _____

Order of Strokes

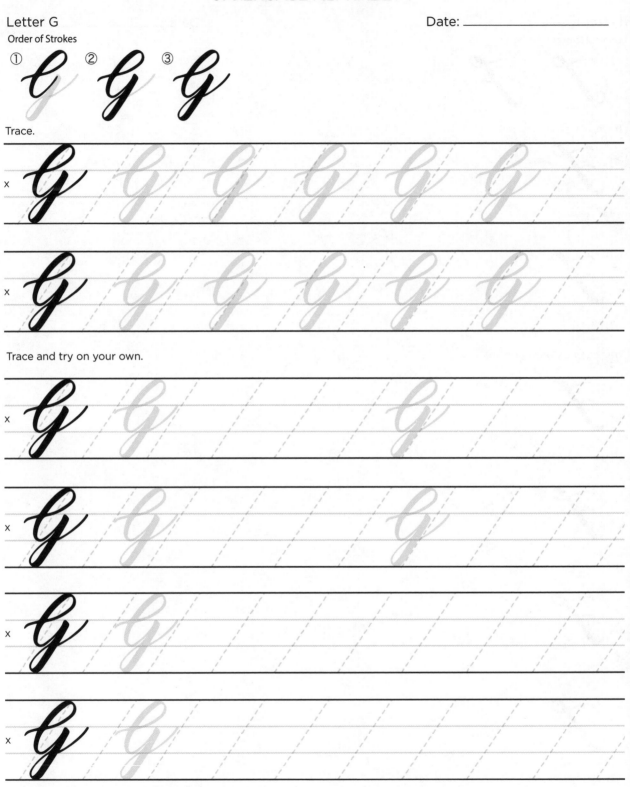

Trace.

Trace and try on your own.

Letter H

Date: _____

Order of Strokes

① ② ③

Trace.

x

x

Trace and try on your own.

x

x

x

x

UPPERCASE ALPHABET

Letter I

Date: _____

Order of Strokes

① ②

Trace.

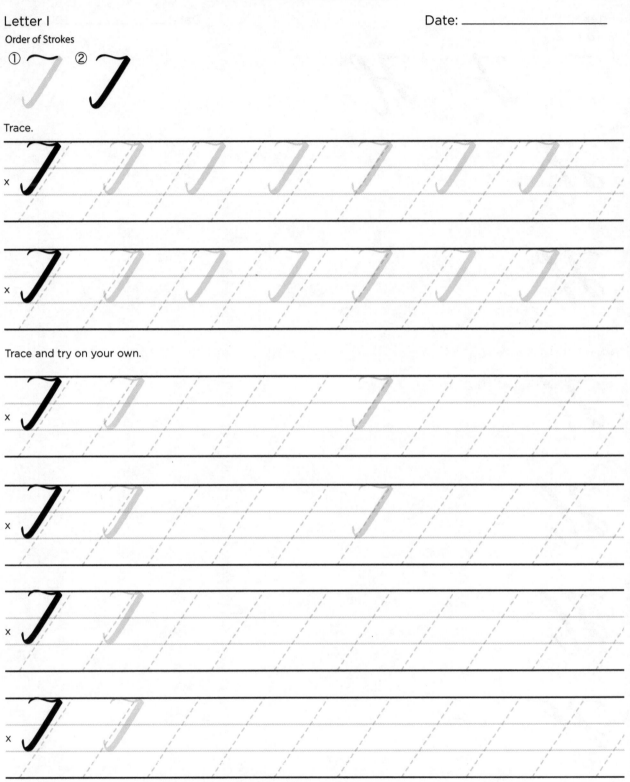

Trace and try on your own.

Brush Pen Lettering Practice Book

Letter J

Date: _____

Order of Strokes

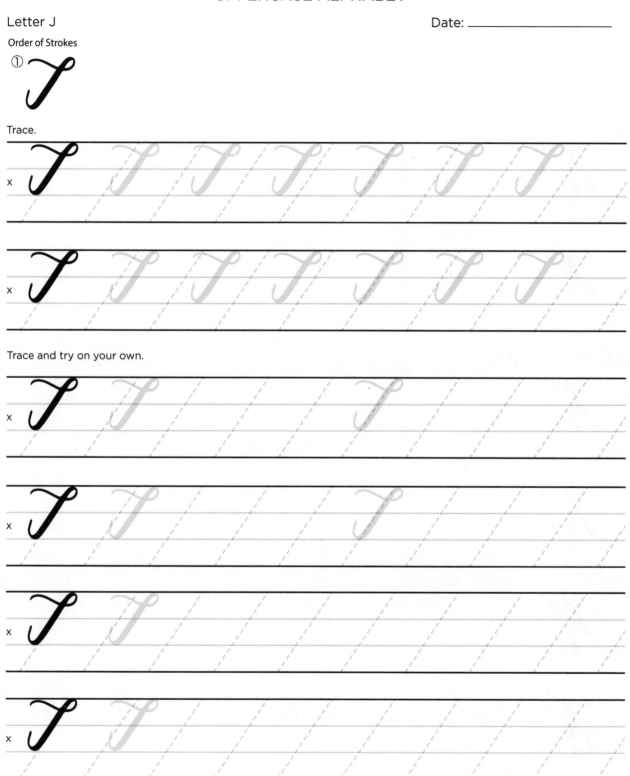

Trace.

Trace and try on your own.

Letter K

Order of Strokes

① ② ③ ④

Trace.

x

x

Trace and try on your own.

x

x

x

x

Letter L Date: _____

Order of Strokes

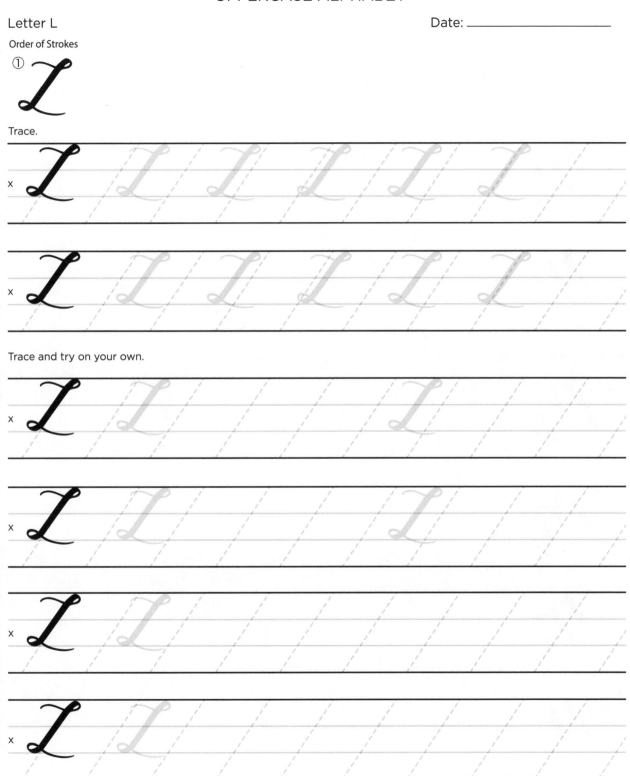

Trace.

Trace and try on your own.

Letter M

Order of Strokes

① ② ③ ④

Trace.

x

x

Trace and try on your own.

x

x

x

x

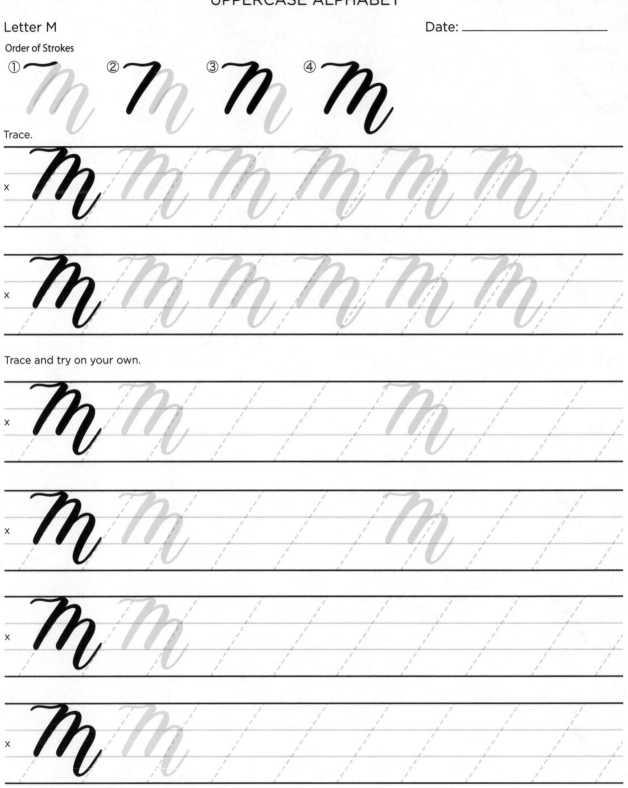

UPPERCASE ALPHABET

Letter N

Order of Strokes

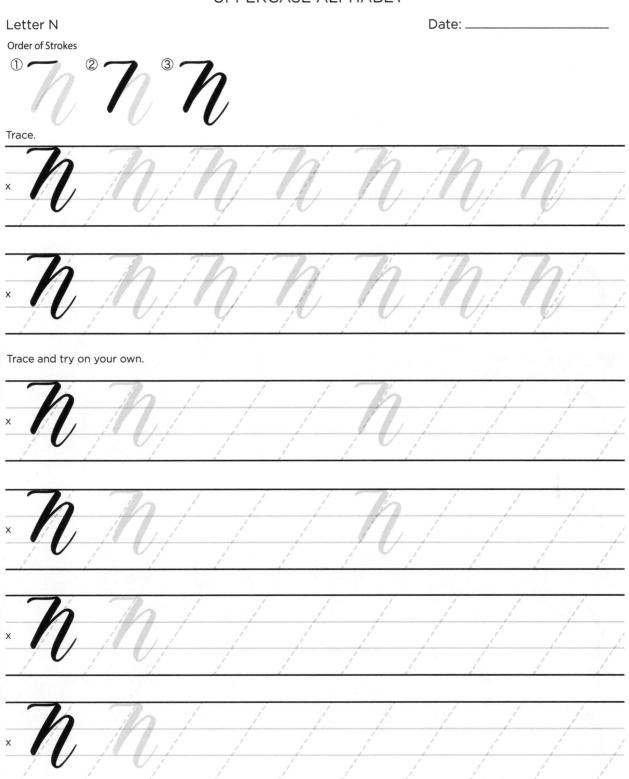

Trace.

Trace and try on your own.

Letter O

Date: _____

Order of Strokes

①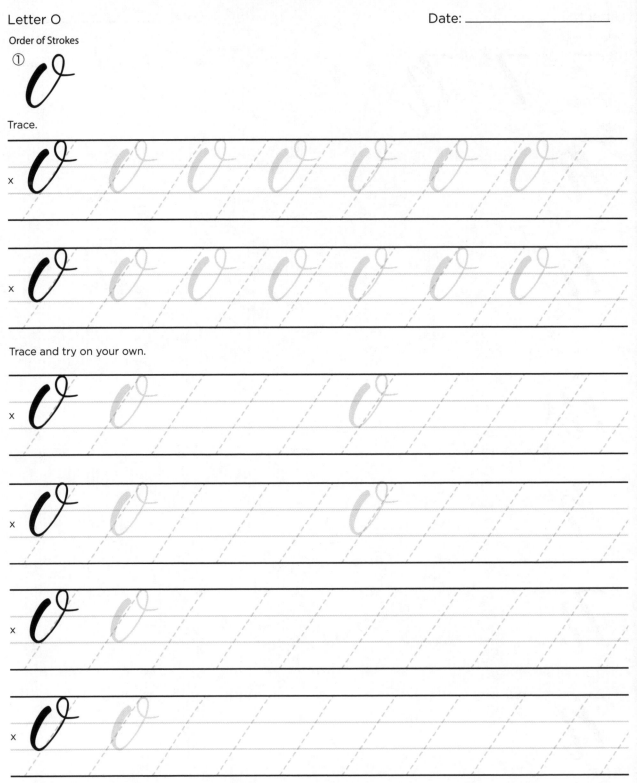

Trace.

x

x

Trace and try on your own.

x

x

x

x

Letter P

Date: _____

Order of Strokes

① ② ③ 𝒫

Trace.

x

x

Trace and try on your own.

x

x

x

x

Letter Q

Order of Strokes

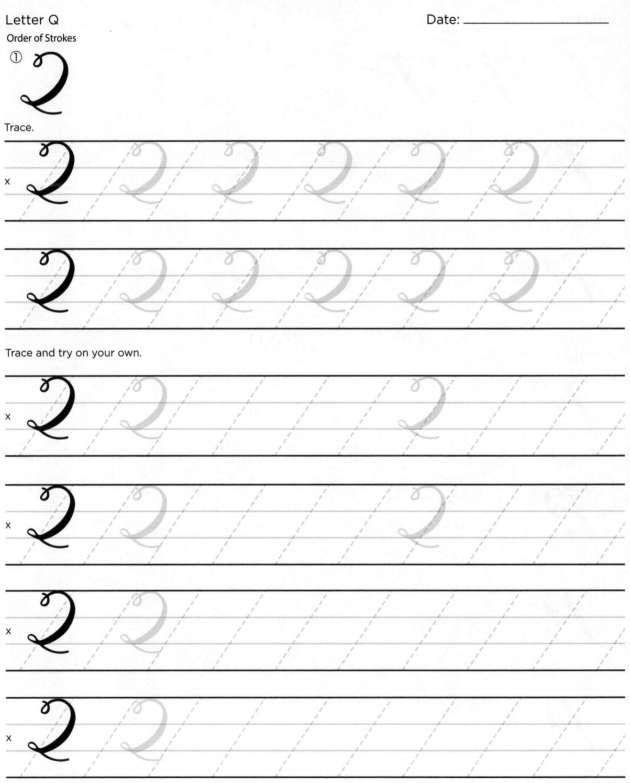

Trace.

Trace and try on your own.

Letter R

Date: _____

Order of Strokes

① ② ③ ④

Trace.

Trace and try on your own.

Letter S

Date: _____

Order of Strokes

①

Trace.

Trace and try on your own.

Letter T

Date: _____

Order of Strokes

Trace.

Trace and try on your own.

Letter U

Order of Strokes

① ② ③

Trace.

x

x

Trace and try on your own.

x

x

x

x

Letter V

Date: _____

Order of Strokes

Trace.

Trace and try on your own.

Letter W

Date: _____

Order of Strokes

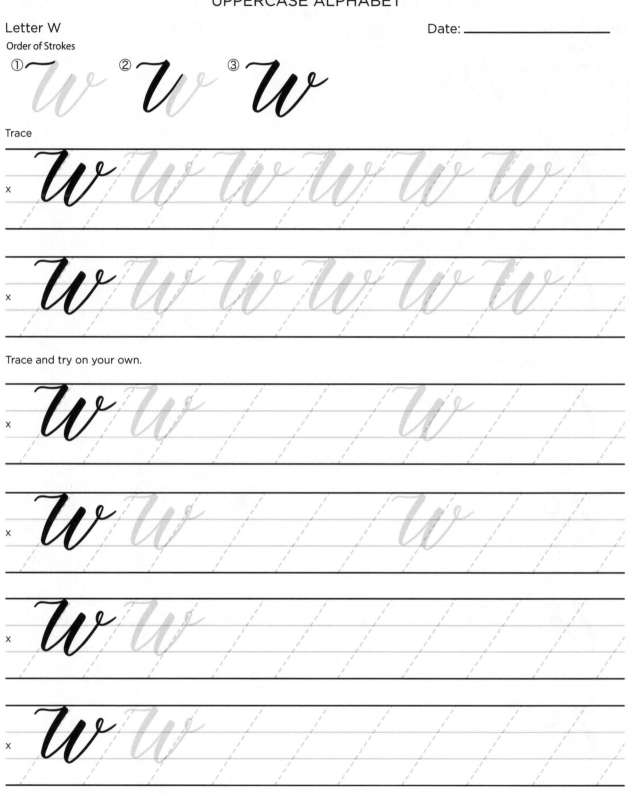

Trace

Trace and try on your own.

Letter X

Date: _____

Order of Strokes

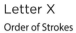

Trace.

Trace and try on your own.

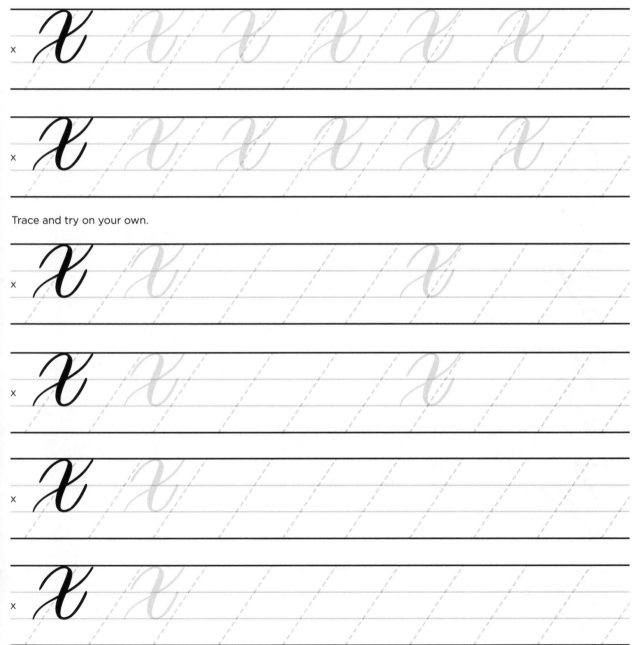

Letter Y

Order of Strokes

① ② ③ ④

Trace.

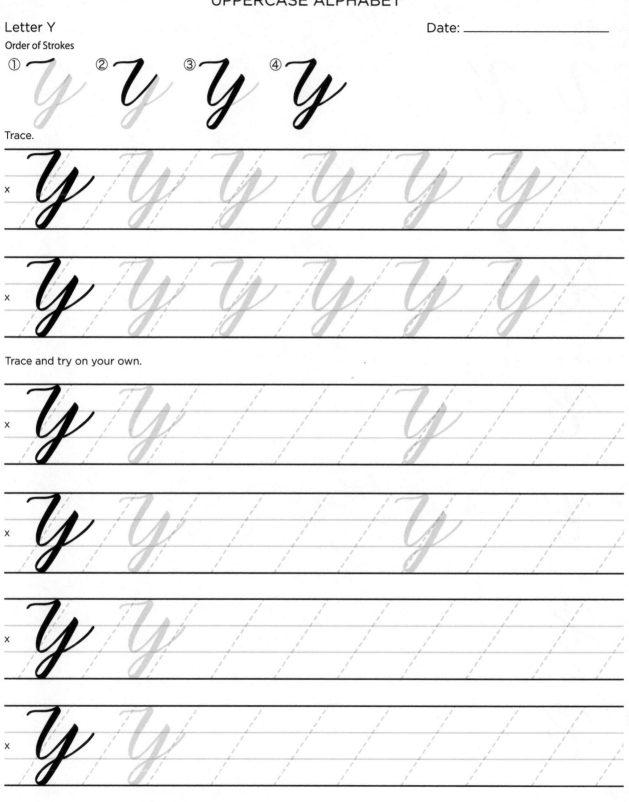

Trace and try on your own.

Letter Z

Order of Strokes

① ② ③

Trace.

x

x

Trace and try on your own.

x

x

x

x

Date: _____

CHAPTER 8

Connecting Letters

Now that you're comfortable with strokes, connecting strokes, and the letterforms, the next step is to connect the letterforms.

I have divided letter connections into three major groups: simple connections, oval connections, and modified connections.

Simple Connections

The last stroke of a letterform is considered the exit stroke and the first stroke of a letterform is considered its entrance stroke.

When connecting one letterform to another, the exit stroke becomes your connecting stroke.

For simple connections, you will only need to remove the entrance stroke of the second letterform.

Drop the gray stroke.

x *a* + *w* = *aw*

x *j* + *i* = *ji*

x *g* + *h* = *gh*

Oval Connections

The connecting stroke is shortened; i.e., it only goes about two thirds of the way up to the waistline.

The entrance stroke of the second letterform is dropped, as in a simple connection.

Shortening the connecting stroke before connecting to an oval allows for a cleaner, smoother connection.

Shorten the connecting stroke.

x *e* + *e* = *ee*

x *t* + *o* = *to*

x *a* + *d* = *ad*

Modified Connection

The connecting stroke between the two letterforms needs to be modified altogether. You could think of it in two different ways:

1. Removing the exit stroke of the first letterform and the entrance stroke of the second letterform and replacing them with a modified connection

2. Blending the exit stroke of the first letterform and the entrance stroke of the second letterform to make a hybrid connection

Either way, this modified connection is done in one stroke/motion. Visualizing how the letterforms will connect before putting pen to paper is key.

Modify the connecting stroke.

CONNECTING LOWERCASE LETTERS

Simple Connections

Drop the gray entrance stroke before connecting the next letter.

$a + b = ab$ *ab* *ab* *ab*

$a + i = ai$ *ai* *ai* *ai*

$c + h = ch$ *ch* *ch* *ch*

$c + k = ck$ *ck* *ck* *ck*

$e + i = ei$ *ei* *ei* *ei*

$f + r = fr$ *fr* *fr* *fr*

$h + t = ht$ *ht* *ht* *ht*

CONNECTING LOWERCASE LETTERS

Simple Connections

Drop the gray entrance stroke before connecting the next letter.

x *m* + *b* = *mb* *mb mb mb*

x *o* + *u* = *ou* *ou ou ou*

x *p* + *h* = *ph* *ph ph ph*

x *s* + *h* = *sh* *sh sh sh*

x *t* + *h* = *th* *th th th*

x *u* + *i* = *ui* *ui ui ui*

x *w* + *h* = *wh* *wh wh wh*

CONNECTING LOWERCASE LETTERS

Oval Connections

Shorten the exit stroke of the first letter and drop the entrance stroke of the next letter.

x *a* + *e* = *ae* *ae* *ae* *ae*

x *d* + *g* = *dg* *dg* *dg* *dg*

x *e* + *a* = *ea* *ea* *ea* *ea*

x *i* + *e* = *ie* *ie* *ie* *ie*

x *n* + *g* = *ng* *ng* *ng* *ng*

x *o* + *a* = *oa* *oa* *oa* *oa*

x *t* + *c* = *tc* *tc* *tc* *tc*

CONNECTING LOWERCASE LETTERS

Modified Connections

The modified connection, a.k.a. the hybrid connection, is created with one complete stroke/motion.

x *a* + *n* = *an* *an* *an* *an*

x *a* + *n* = *an* *an* *an* *an*

x *a* + *y* = *ay* *ay* *ay* *ay*

x *i* + *n* = *in* *in* *in* *in*

x *a* + *v* = *av* *av* *av* *av*

x *a* + *x* = *ax* *ax* *ax* *ax*

x *h* + *n* = *hn* *hn* *hn* *hn*

CONNECTING LOWERCASE LETTERS

Modified Connections

Date: _____

The modified connection, a.k.a. the hybrid connection, is created with one complete stroke/motion.

x _h_ + _v_ = _hv_ _hv_ _hv_ _hv_

x _m_ + _n_ = _mn_ _mn_ _mn_

x _n_ + _v_ = _nv_ _nv_ _nv_ _nv_

x _n_ + _n_ = _nn_ _nn_ _nn_ _nn_

x _x_ + _y_ = _xy_ _xy_ _xy_ _xy_

x _d_ + _m_ = _dm_ _dm_ _dm_

x _l_ + _v_ = _lv_ _lv_ _lv_ _lv_

CONNECTING LOWERCASE LETTERS

Modified Connections

Note that a modified or hybrid connection may need to be "squeezed" to adjust for spacing between letters.

x *v* + *n* = *vn* *vn* *vn* *vn*

x *o* + *n* = *on* *on* *on* *on*

x *o* + *v* = *ov* *ov* *ov* *ov*

x *v* + *y* = *vy* *vy* *vy* *vy*

x *b* + *y* = *by* *by* *by* *by*

x *k* + *n* = *kn* *kn* *kn* *kn*

x *e* + *y* = *ey* *ey* *ey* *ey*

CONNECTING LOWERCASE LETTERS

Date: _____

Some of these connections are simple and others require modification.

x *b* + *r* = *br* br br br

x *b* + *y* = *by* by by by

x *d* + *i* = *di* di di di

x *e* + *r* = *er* er er er

x *e* + *y* = *ey* ey ey ey

x *k* + *n* = *kn* kn kn kn

x *l* + *m* = *lm* lm lm lm

Alternative Connections

Some of these connections are simple and others require modification.

Date: _____

x *m* + *m* = *mm* *mm* *mm*

x *n* + *n* = *nn* *nn* *nn* *nn*

x *v* + *r* = *vr* *vr* *vr* *vr*

x *v* + *v* = *vv* *vv* *vv* *vv*

x *p* + *r* = *pr* *pr* *pr* *pr*

x *p* + *y* = *py* *py* *py* *py*

x *r* + *n* = *rn* *rn* *rn* *rn*

CONNECTING LOWERCASE LETTERS

Alternative Connections

Some of these connections are simple and others require modification.

x *s* + *h* = *sh* sh sh sh

x *s* + *t* = *st* st st st

x *t* + *h* = *th* th th th

x *v* + *l* = *vl* vl vl vl

x *v* + *r* = *vr* vr vr vr

x *w* + *h* = *wh* wh wh wh

x *u* + *v* = *uv* uv uv uv

CONNECTING UPPER TO LOWERCASE

Simple Connections

Date: _____

Remove the entrance stroke of the lowercase letter.

x *A* + *b* = *Ab* *Ab* *Ab* *Ab*

x *H* + *a* = *Ha* *Ha* *Ha* *Ha*

x *K* + *i* = *Ki* *Ki* *Ki* *Ki*

x *M* + *o* = *Mo* *Mo* *Mo* *Mo*

x *N* + *e* = *Ne* *Ne* *Ne* *Ne*

x *R* + *i* = *Ri* *Ri* *Ri* *Ri*

x *U* + *l* = *Ul* *Ul* *Ul* *Ul*

Simple Connections

Date: _____

Remove the entrance stroke of the lowercase letter.

x \mathcal{B} + e = \mathcal{Be} *Be* *Be* *Be*

x \mathcal{C} + h = \mathcal{Ch} *Ch* *Ch* *Ch*

x \mathcal{D} + e = \mathcal{De} *De* *De* *De*

x \mathcal{E} + f = \mathcal{Ef} *Ef* *Ef* *Ef*

x \mathcal{G} + o = \mathcal{Go} *Go* *Go* *Go*

x \mathcal{S} + t = \mathcal{St} *St* *St* *St*

x \mathcal{Y} + e = \mathcal{Ye} *Ye* *Ye* *Ye*

CONNECTING UPPER TO LOWERCASE

Modified Connections

Remove the exit stroke of the uppercase letter and the entrance stroke of the lowercase letter. Replace with a modified connection.

x $A + z = Az$ Az Az Az

x $A + v = Av$ Av Av Av

x $B + y = By$ By By By

x $C + n = Cn$ Cn Cn Cn

x $C + x = Cx$ Cx Cx Cx

x $U + m = Um$ Um Um Um

x $X + y = Xy$ Xy Xy Xy

CONNECTING UPPER TO LOWERCASE

Modified Connections

In most of these connections, the stroke connecting the two
letters is completed in one motion.

x \mathcal{V} + b = $\mathcal{V}b$ $\mathcal{V}b$ $\mathcal{V}b$ $\mathcal{V}b$

x \mathcal{V} + k = $\mathcal{V}k$ $\mathcal{V}k$ $\mathcal{V}k$ $\mathcal{V}k$

x \mathcal{V} + l = $\mathcal{V}l$ $\mathcal{V}l$ $\mathcal{V}l$ $\mathcal{V}l$

x \mathcal{P} + h = $\mathcal{P}h$ $\mathcal{P}h$ $\mathcal{P}h$ $\mathcal{P}h$

x \mathcal{P} + l = $\mathcal{P}l$ $\mathcal{P}l$ $\mathcal{P}l$ $\mathcal{P}l$

x \mathcal{W} + h = $\mathcal{W}h$ $\mathcal{W}h$ $\mathcal{W}h$ $\mathcal{W}h$

x \mathcal{W} + o = $\mathcal{W}o$ $\mathcal{W}o$ $\mathcal{W}o$

CONNECTING UPPER TO LOWERCASE

These uppercase letters can stand alone depending on which lowercase letter comes next. Just remove the entrance stroke of the lowercase letter and leave a space.

Date: _____

x $I + s = Is$ Is Is Is

x $J + i = Ji$ Ji Ji Ji

x $L + o = Lo$ Lo Lo Lo

x $O + c = Oc$ Oc Oc Oc

x $P + a = Pa$ Pa Pa Pa

x $Q + u = Qu$ Qu Qu Qu

x $W + e = We$ We We We

CHAPTER 9

Words

The next challenge is to write whole words! The following exercises help you to letter common words that you can use on letters, greeting cards, gift tags, invitations, and so on. They include many of the two-letter combinations you worked on previously.

When practicing whole words, it is important to not rush and give much attention to each and every stroke. It is common to see at this stage of learning, a lack of contrast between the upstrokes and downstrokes when writing whole words. So, although it's important to anticipate the connections between each letter, try focusing on one stroke at a time and be mindful of pen tip placement and where to apply light and heavy pressures.

THEME: Snail Mail Date: _____

x Hello

x Hey

x Dear

x Love

x Sincerely

x Yours truly

x Best wishes

THEME: Invitations Date: _____

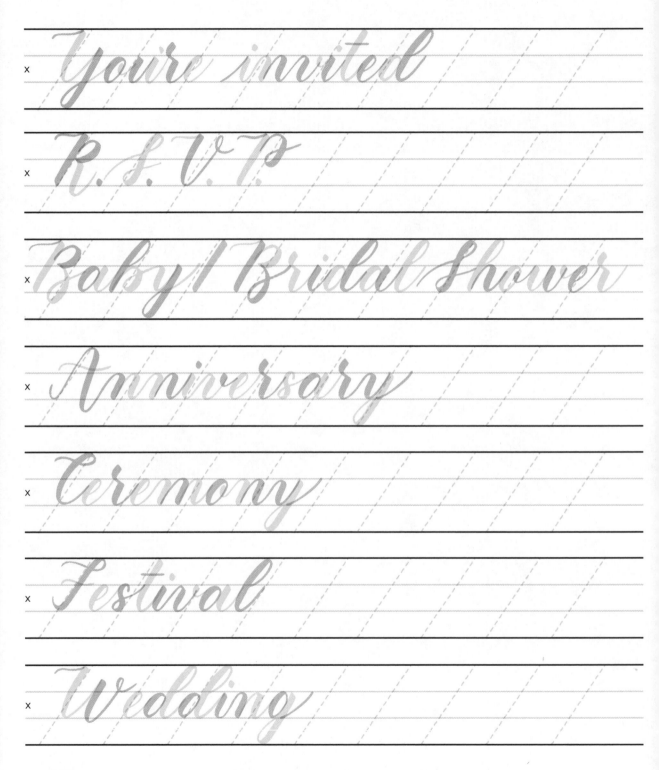

x You're invited

x R.S.V.P.

x Baby/ Bridal Shower

x Anniversary

x Ceremony

x Festival

x Wedding

WORDS

THEME: Celebrations Date: _____

x Cheers

x Happy Birthday

x Congratulations

x Greetings

x Honor

x Celebration

x Party

WORDS

THEME: Tea

Date: _____

x *Earl Grey*

x *Matcha*

x *Oolong*

x *Darjeeling*

x *Chai*

x *English Breakfast*

x *Rooibos*

THEME: Flowers

Date: _____

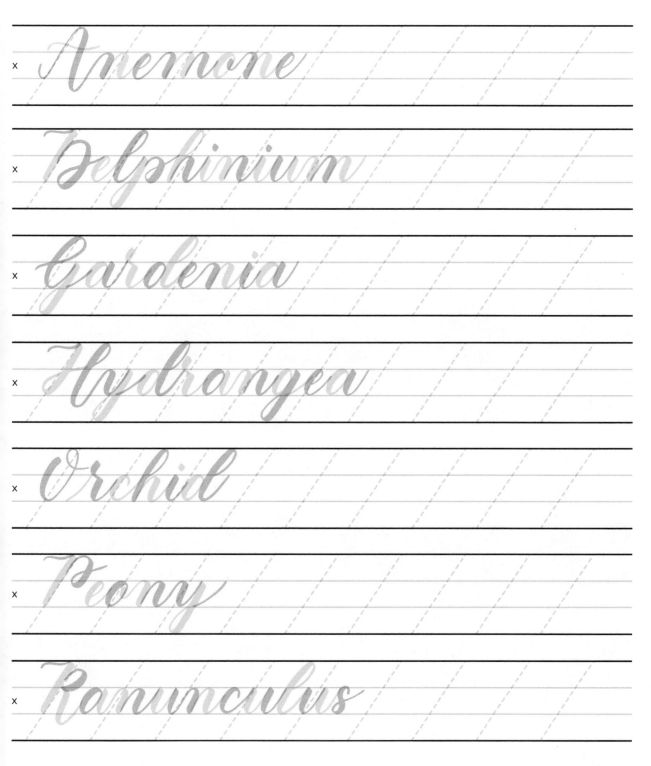

x Anemone

x Delphinium

x Gardenia

x Hydrangea

x Orchid

x Peony

x Ranunculus

WORDS

THEME: Days of the Week Date: _____

x *Sunday*

x *Monday*

x *Tuesday*

x *Wednesday*

x *Thursday*

x *Friday*

x *Saturday*

WORDS

THEME: Months of the Year

Date: _____

x *January*

x *February*

x *March*

x *April*

x *May*

x *June*

x *July*

WORDS

x August

x September

x October

x November

x December

x month

x year

Numbers and Symbols

Numbers and common symbols will come in handy when lettering addresses on envelopes, creating invitations, and making table numbers and guest seating charts for special events, just to name a few ideas.

NUMBERS AND SYMBOLS

Date: _____

NUMBERS & SYMBOLS

Date: _____

x 8 8 8 8

x 9 9 9 9

x 0 0 0 0

x / / / /

x ? ? ? ?

x @ @ @

x E E E E

CHAPTER 11

Developing Style

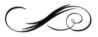

Up to this point in the book, you have been practicing a basic script. You can now build on that script to develop your own style!

Start by playing around with the guidelines and see what you like best. So far, the space between each of the guidelines has had a 1:1:1 ratio. If you keep the x-height the same but double the space between the ascender and the waistline and the space between the baseline and the descender (creating a 2:1:2 ratio), the letters lengthen, look skinnier, and more elegant. However, if you double the x-height to create a 1:2:1 ratio between the guidelines, you tend to create a bubbly, playful look.

Bouncy lettering is a hugely popular way to give your letters personality. It is characterized by letters that appear as if they are dancing or bouncing up and down. In this style of lettering, you must understand that for each letter, the bulk of its weight is where the center of gravity is. When the center of gravity for each letter lies around the same level, you can extend strokes either below the baseline or above the waistline to make the letters appear like they are "bouncing."

Flourishes are loops and swirls that you can use to decorate your letters and words in a whimsical way. When learning how to flourish, it's a good idea to start with a pencil to build muscle memory for the curved lines and oval shapes. Try the exercises in pencil repeatedly, then once you're comfortable, use a brush pen. In the exercises that follow, you will practice some basic flourishing shapes and see how they can be applied to individual letters and within words.

ELEGANT LETTER EXEMPLAR

RATIO: 2:1:2 SLANT: 55 degrees

Date: _____

x

a b c d e

x

f g h i j k

x

l m n o p

x

q r s t u

x

v w x y z

ELEGANT STYLE WORDS

THEME: Fruit Date: _____

x *grapefruit*

x *mango*

x *strawberry*

x *pomegranate*

x *cantaloupe*

ELEGANT STYLE WORDS

Date: _____

x *iced coffee*

x *cappuccino*

x *cafe latte*

x *macchiato*

x *flat white*

RATIO: 1:2:1 SLANT: 55 degrees Date: _____

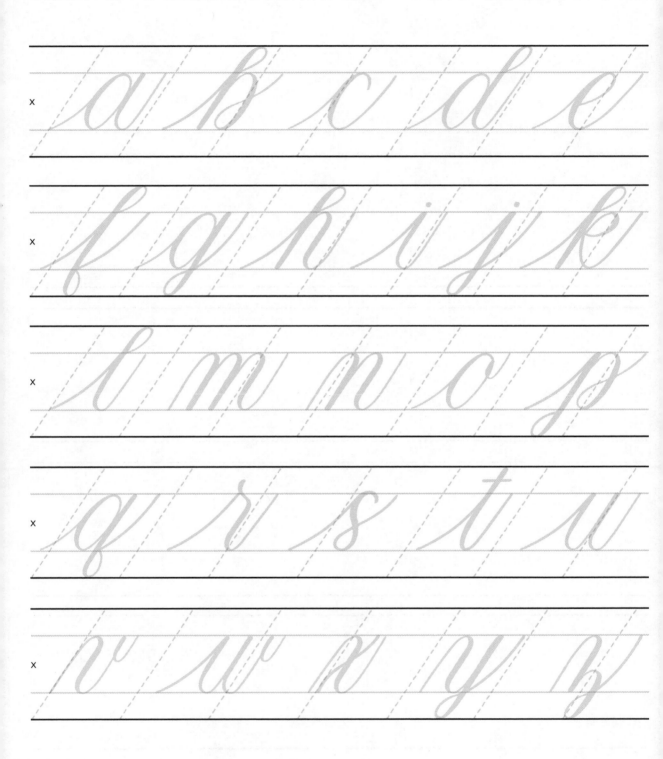

PLAYFUL STYLE WORDS

THEME: Colors

Date: _____

x red

x orange

x yellow

x green

x teal

PLAYFUL STYLE WORDS

Date: _____

x *blue*

x *purple*

x *violet*

x *black*

x *white*

BOUNCY LETTER EXEMPLAR

RATIO: 2:1:2 SLANT: 55 degrees

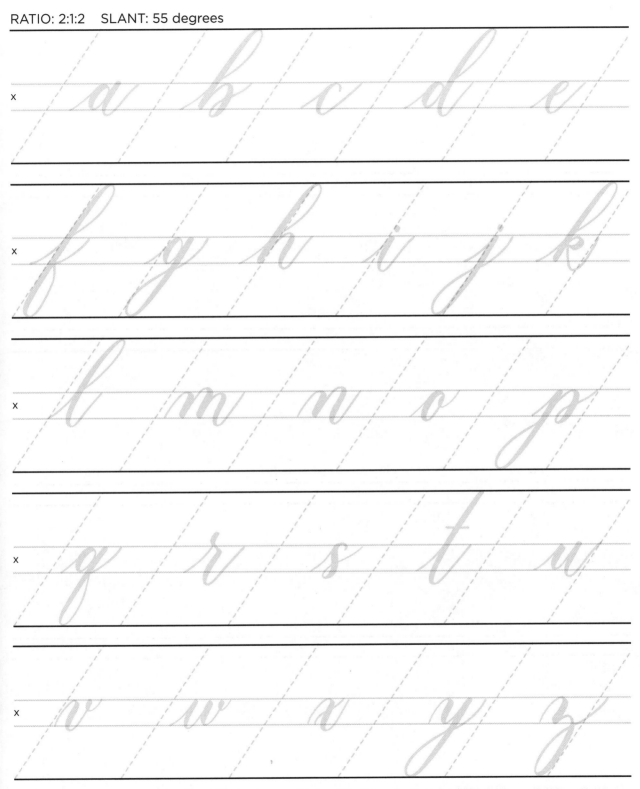

THEME: Desserts

Date: _____

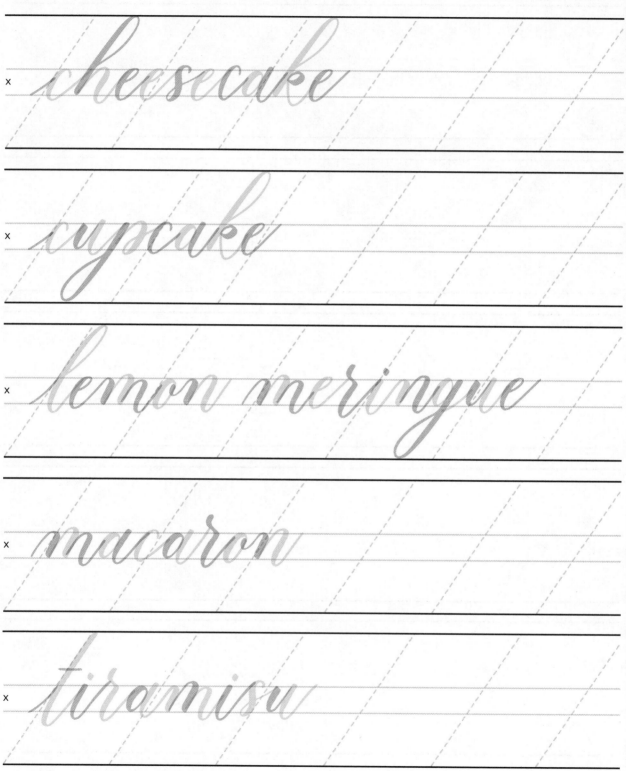

x *cheesecake*

x *cupcake*

x *lemon meringue*

x *macaron*

x *tiramisu*

BOUNCY STYLE WORDS

THEME: Cheese Date: _____

x *brie*

x *cheddar*

x *gouda*

x *mozzarella*

x *parmesan*

FLOURISHES

Flourishes that can be added to letters with descenders.

Date: _____

FLOURISHES

Apply these flourishes to letters like g, j, p, y, and z.

Date: _____

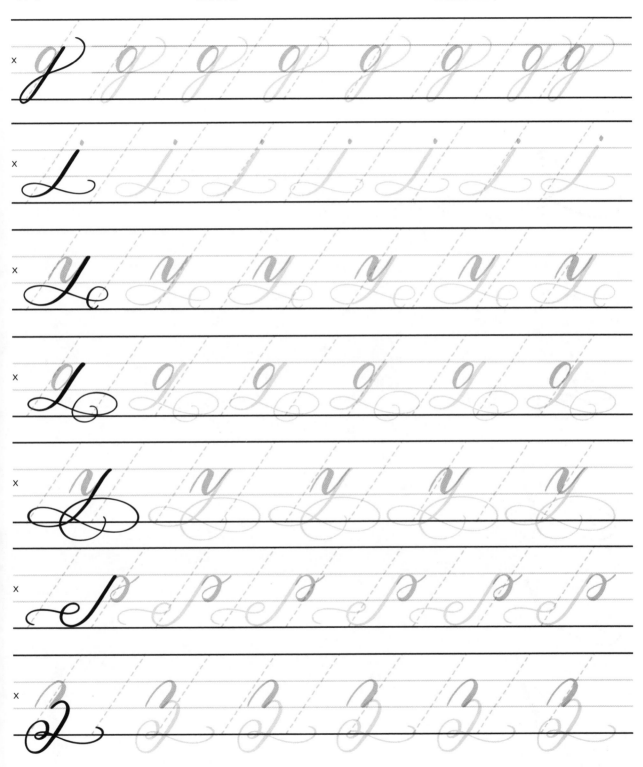

FLOURISHES

Other letters such as h, m, n, and r, can also be flourished.

Date: _____

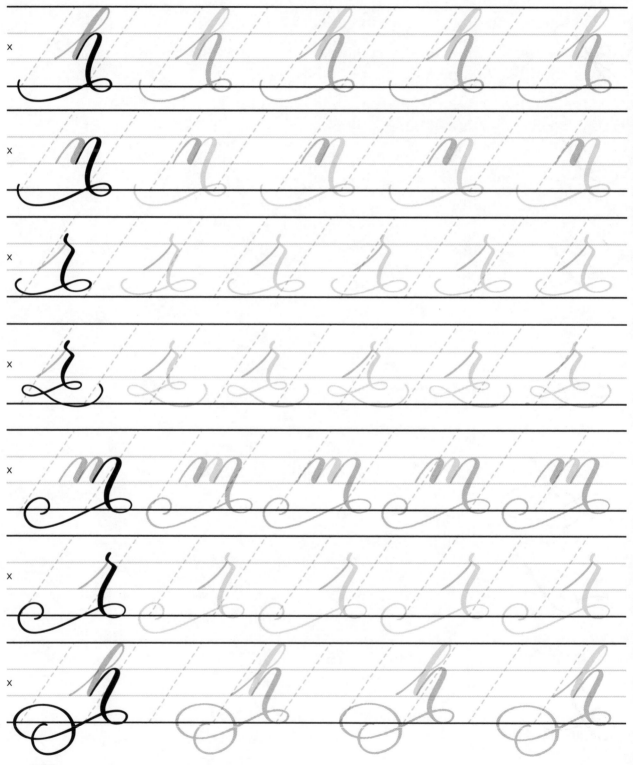

FLOURISHES

These letters can be easily flourished, especially when appearing at the beginning or middle of words.

Date: _____

FLOURISHES

These are examples of how letters can be flourished when they appear at the end of words.

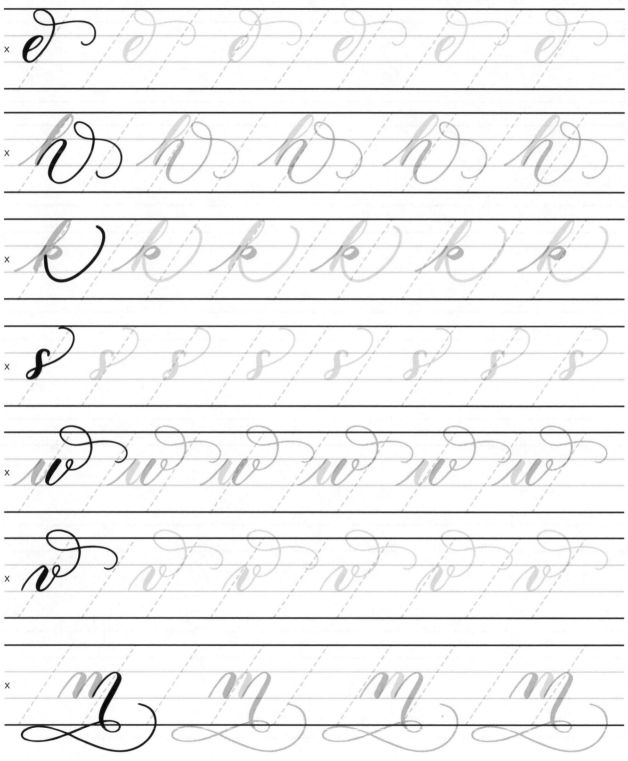

FLOURISHES

The cross stroke of the letter t can be flourished in many ways to give it more personality. It can also be combined with the top of another letter like d, f, h, and k.

x

x

x

x

x

x

x

FLOURISHED WORDS

THEME: Family Date: _____

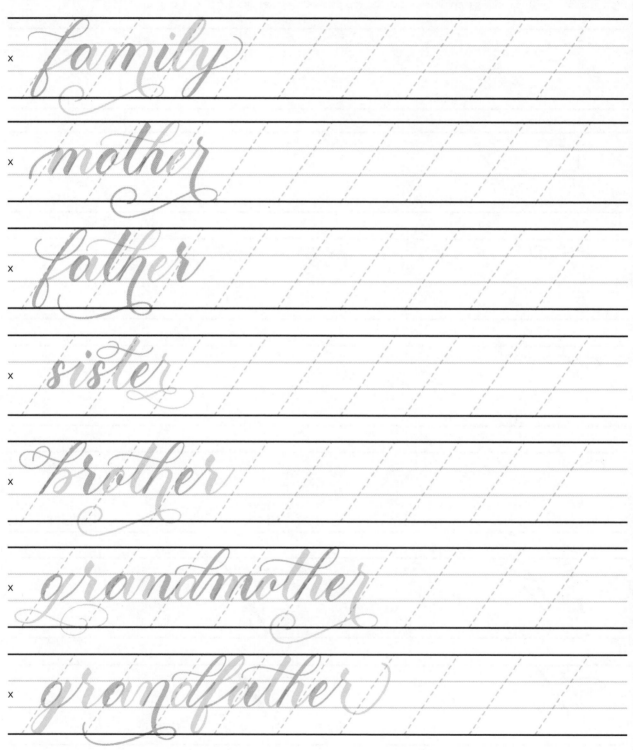

x *family*

x *mother*

x *father*

x *sister*

x *brother*

x *grandmother*

x *grandfather*

FLOURISHED WORDS

THEME: Family Date: _____

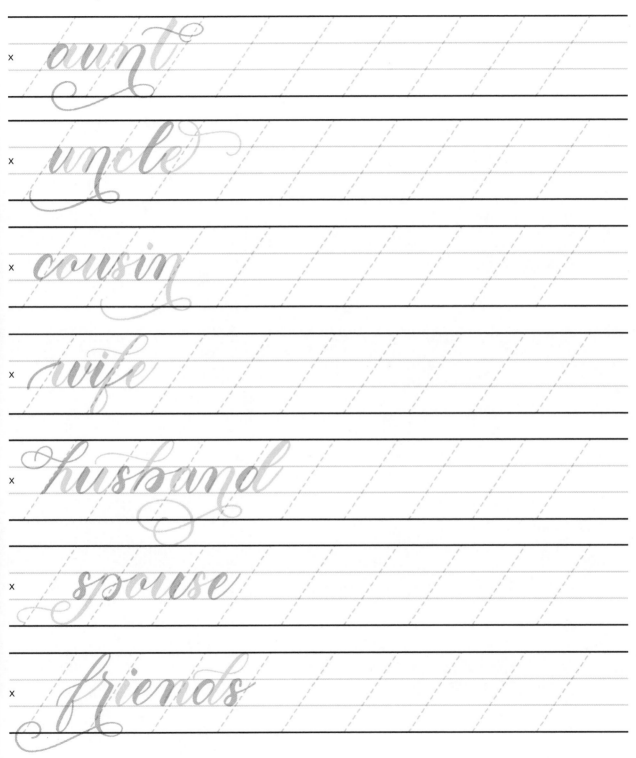

x aunt

x uncle

x cousin

x wife

x husband

x spouse

x friends

FLOURISHED WORDS

THEME: Words where the cross stroke of the letter t is combined with a stroke of the next letter

Date: _____

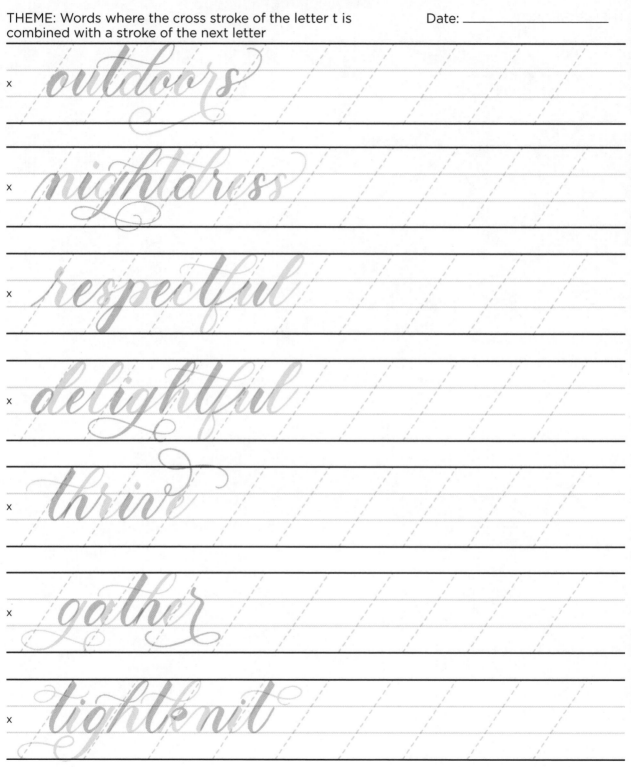

x *outdoors*

x *nightdress*

x *respectful*

x *delightful*

x *thrive*

x *gather*

x *tightknit*

Theme: Quotes

Date: _____

x

Art is

x

as natural as

x

sunshine

x

and as vital

x

as nourishment

x

MaryAnn Kohl

Theme: Quotes Date: _____

x *Learn the rules*

x *like a pro,*

x *so you can*

x *break them*

x *like an artist*

x *Pablo Picasso*

Appendix

The following blank guideline sheets are provided in 3 different line space ratios, with and without slant lines. Use these guidelines to your heart's content when practicing!

The guidelines with a line space ratio of 1:1:1 HAVE been used for the majority of this practice book. The guidelines with a line space ratio of 1:2:1 can be used to create playful lettering and the guidelines with a line space ratio of 2:1:2 can be used to create elegant lettering.

GUIDELINES

RATIO: 1:1:1 SLANT: 55 degrees

Date: _____

GUIDELINES

RATIO: 1:1:1 SLANT: none

Date: _____

x

x

x

x

x

x

x

GUIDELINES

RATIO: 1:2:1 SLANT: 55 degrees

Date: _____

x

x

x

x

x

GUIDELINES

RATIO: 1:2:1 SLANT: none

Date: _____

x

x

x

x

x

GUIDELINES

RATIO: 2:1:2 SLANT: 55 degrees Date: _____

x

x

x

x

x

GUIDELINES

Date: _____

x

x

x

x

x

About the Author

Grace Song is a hand-letterer and brush calligraphy artist based in Toronto, Canada. She loves helping clients find the right hand-made touch to fit their needs whether they be for one-of-a-kind pieces, wedding stationery, digitized lettered designs, or live events. As an elementary school teacher by day, Grace combines her love of teaching with her passion for hand-lettering by teaching workshops that cover all the basics and more. She also shares all her knowledge and tips in her widely celebrated instructional book called *Brush Pen Lettering*. You can find Grace locally at meet-ups organized with fellow enthusiastic hand-letterers and calligraphers or virtually via Facebook or Instagram (@gracesongcalligraphy).